HOW TO DRAW
SOLDIERS

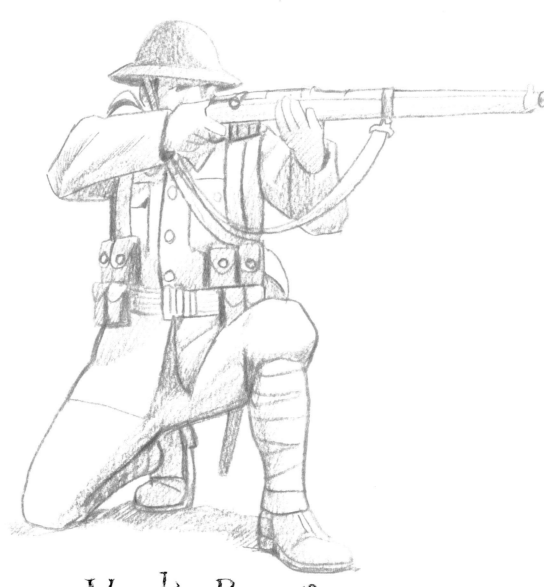

Mark Bergin

PowerKiDS
press™

New York

Published in 2012 by The Rosen Publishing Group, Inc.
29 East 21st Street, New York, NY 10010

Editor: Rob Walker
U.S. Editor: Kara Murray

Library of Congress Cataloging-in-Publication Data

Bergin, Mark.
 Soldiers / by Mark Bergin. — 1st ed.
 p. cm. — (How to draw)
 Includes index.
 ISBN 978-1-4488-6463-8 (library binding) — ISBN 978-1-4488-6473-7 (pbk.)
 — ISBN 978-1-4488-6474-4 (6-pack)
 1. Soldiers in art—Juvenile literature. 2. Drawing—Technique—
Juvenile literature. I. Title. II. Series.
 NC825.W37B47 2012
 743.4—dc22

2011017653

Manufactured in China

CPSIA Compliance Information: Batch #SW2102PK:
For Further Information contact Rosen Publishing,
New York, New York at 1-800-237-9932

PAPER FROM
SUSTAINABLE
FORESTS

Contents

Making a Start

Learning to draw is about looking and seeing. Keep practicing and get to know your subject. Use a sketchbook to make quick drawings. Start by doodling, and experiment with shapes and patterns. There are many ways to draw. This book shows only some methods. Visit art galleries, look at artists' drawings, see how friends draw, but above all, find your own way.

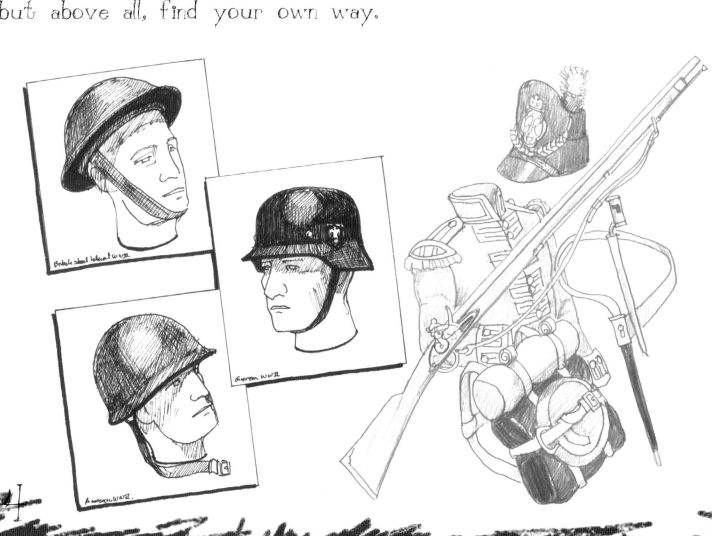

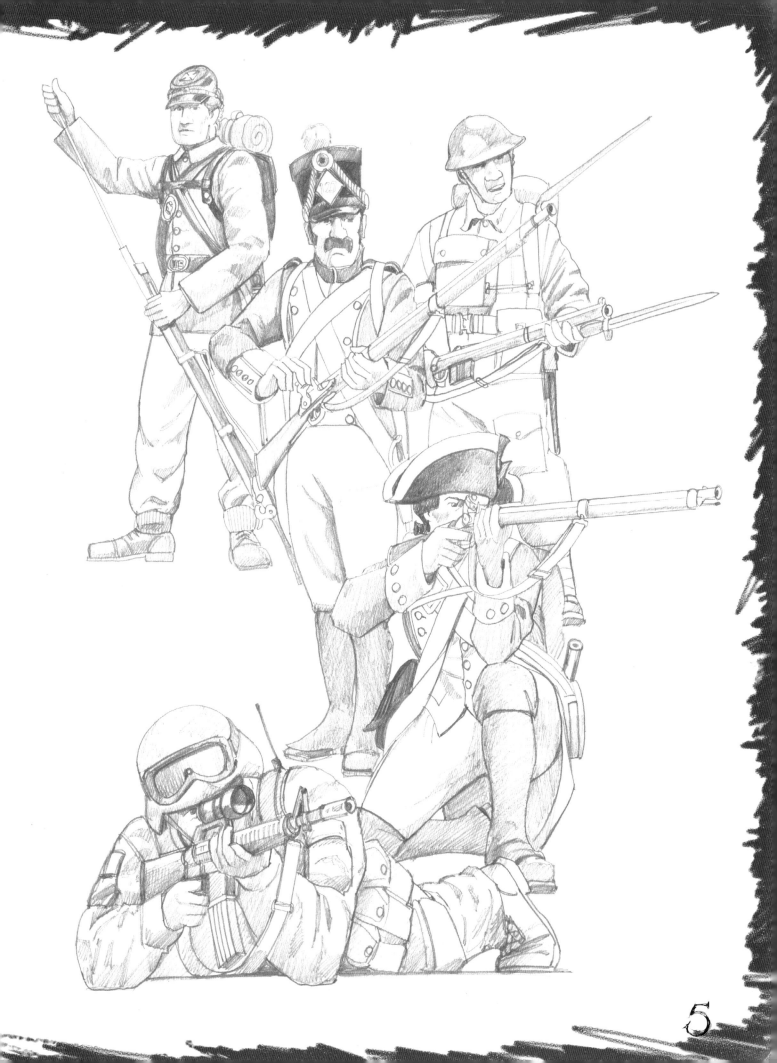

Drawing Materials

Try using different types of drawing paper and materials. Experiment with charcoal, wax crayons, and pastels. All pens, from felt-tips to ballpoints, will make interesting marks. You could also try drawing with pen and ink on wet paper.

Silhouette

Silhouette is a style of drawing that mainly uses solid black shapes.

Pencil

Hard **pencils** are grayer and soft pencils are blacker. Hard pencils are graded #4 (the hardest) through #3 and #2 1/2. A #1 pencil is a soft pencil.

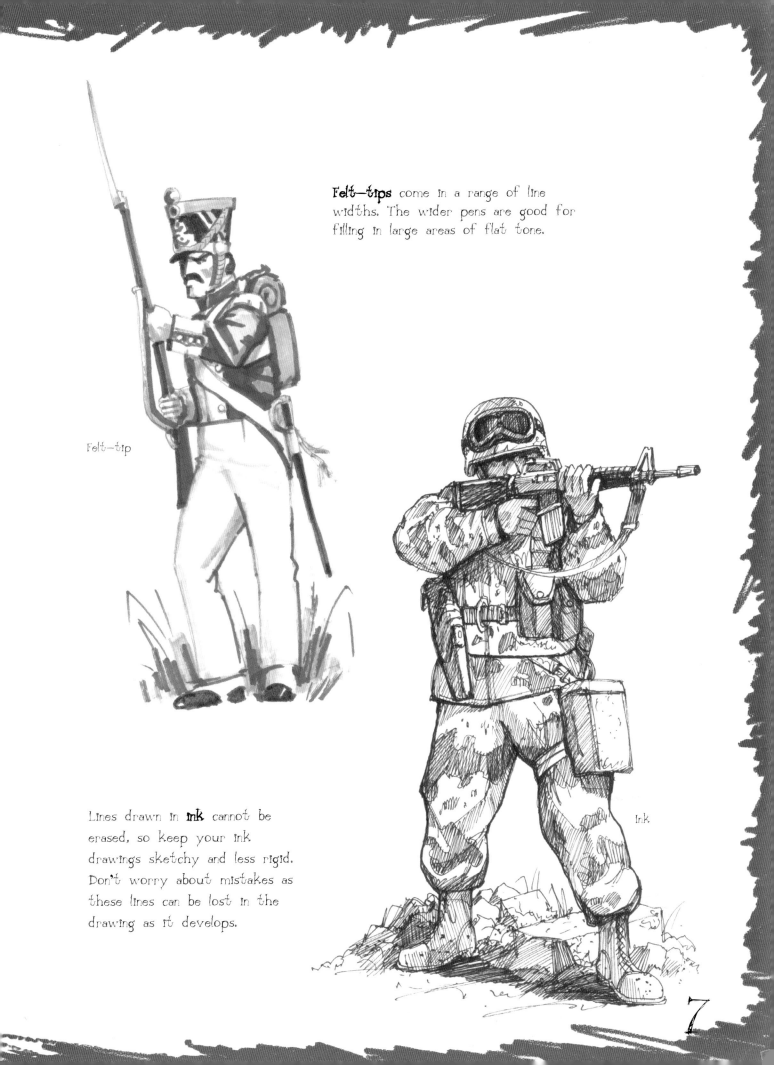

Felt–tips come in a range of line widths. The wider pens are good for filling in large areas of flat tone.

Felt–tip

Lines drawn in **ink** cannot be erased, so keep your ink drawings sketchy and less rigid. Don't worry about mistakes as these lines can be lost in the drawing as it develops.

Ink

Perspective

If you look at any object from different viewpoints, you will see that the part that is closest to you looks larger and the part farthest away from you looks smaller. Drawing in perspective is a way of creating a feeling of depth, or of showing three dimensions on a flat surface.

V.P.

The vanishing point (V.P.) is the place in a perspective drawing where parallel lines appear to meet. The position of the vanishing point depends on the viewer's eye level. Sometimes a low viewpoint can give your drawing added drama.

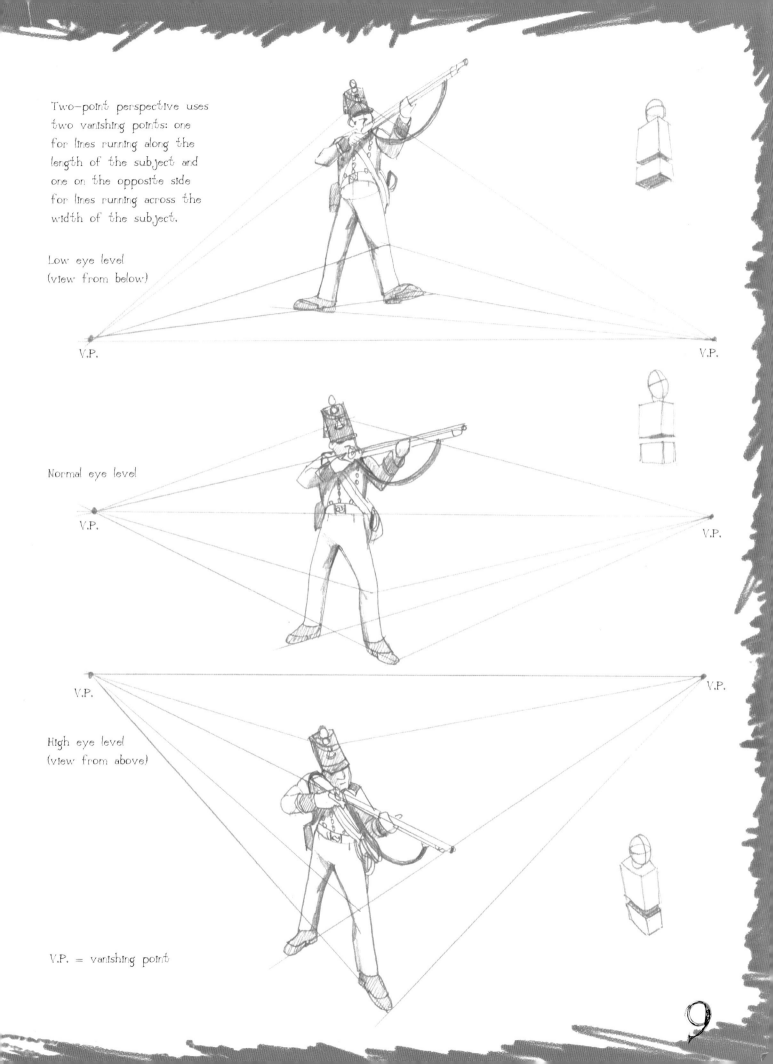

Two-point perspective uses
two vanishing points: one
for lines running along the
length of the subject and
one on the opposite side
for lines running across the
width of the subject.

Low eye level
(view from below)

V.P.

V.P.

Normal eye level

V.P.

V.P.

V.P.

V.P.

High eye level
(view from above)

V.P. = vanishing point

9

Action Poses

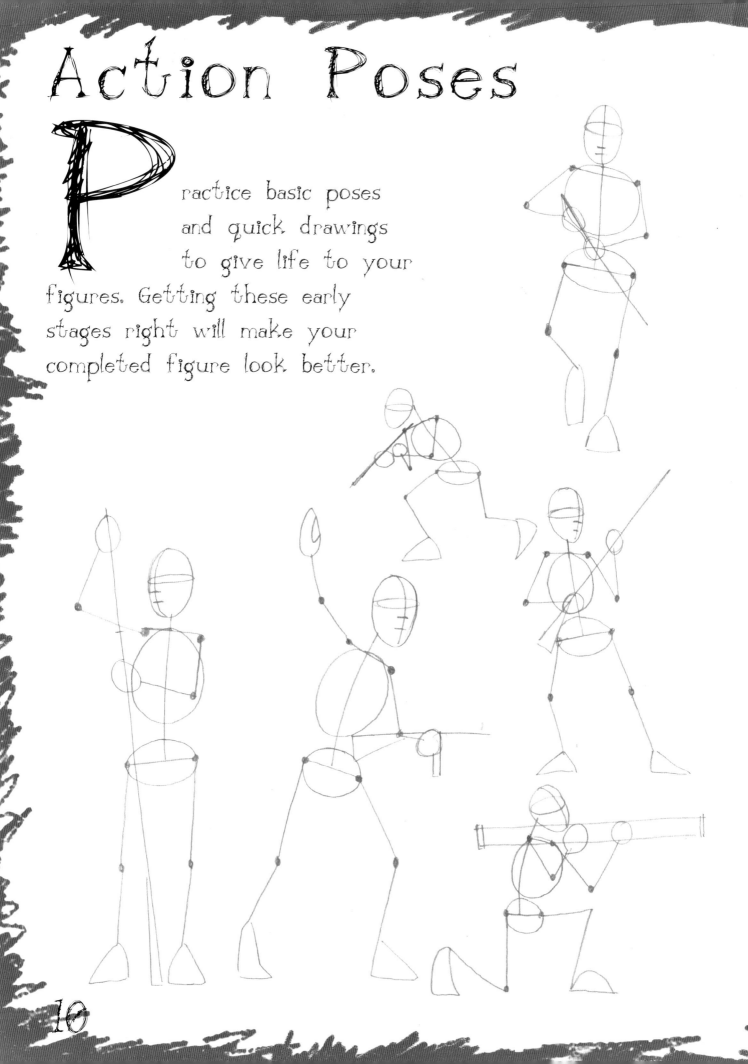

Practice basic poses and quick drawings to give life to your figures. Getting these early stages right will make your completed figure look better.

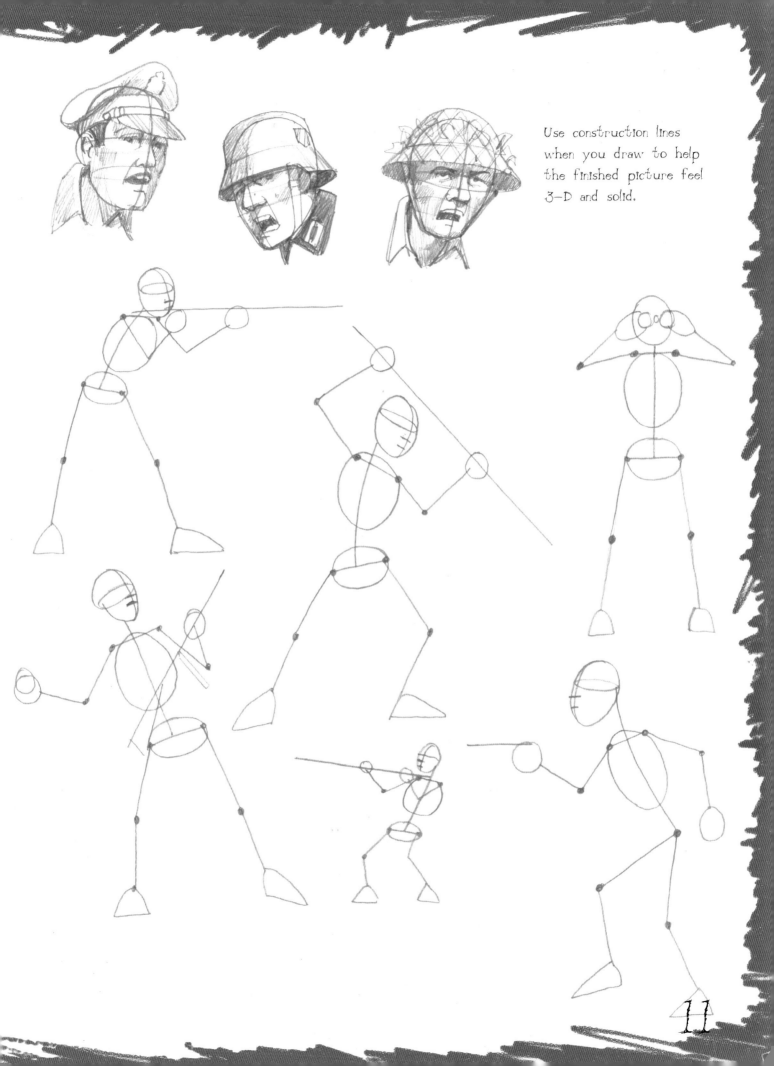

Use construction lines
when you draw to help
the finished picture feel
3-D and solid.

11

Minuteman

Each American colony had a group of volunteer soldiers called minutemen. They were expected to fight at a minute's notice. These soldiers had no uniforms and fought in their everyday clothes.

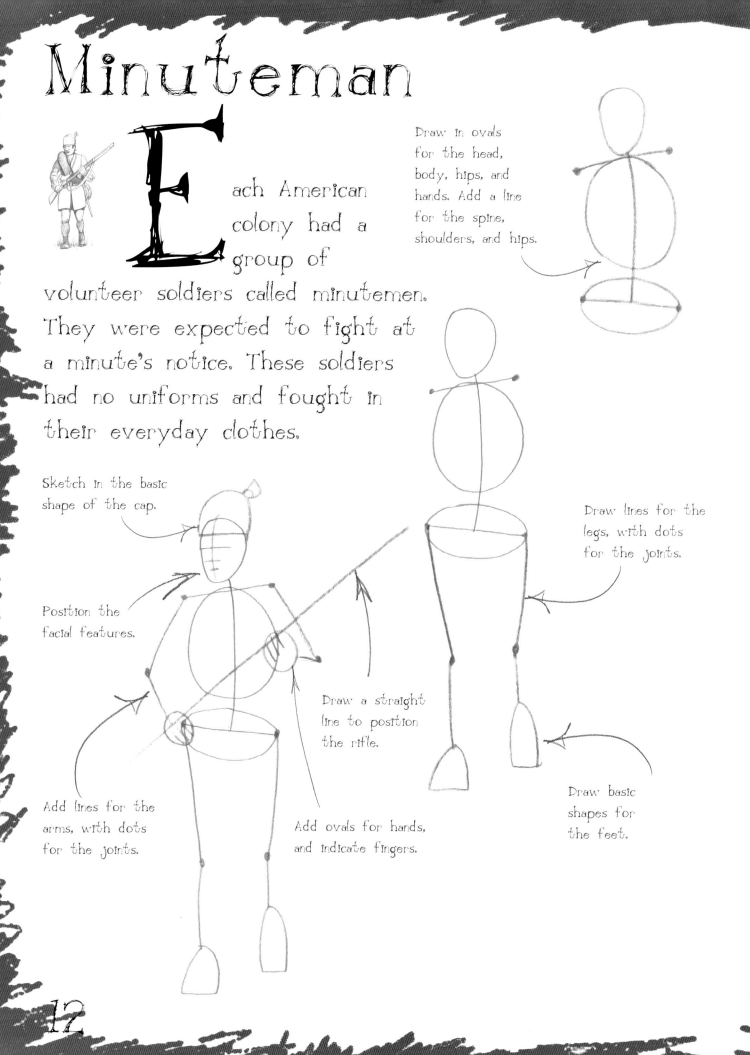

Draw in ovals for the head, body, hips, and hands. Add a line for the spine, shoulders, and hips.

Sketch in the basic shape of the cap.

Position the facial features.

Draw lines for the legs, with dots for the joints.

Draw a straight line to position the rifle.

Add lines for the arms, with dots for the joints.

Add ovals for hands, and indicate fingers.

Draw basic shapes for the feet.

12

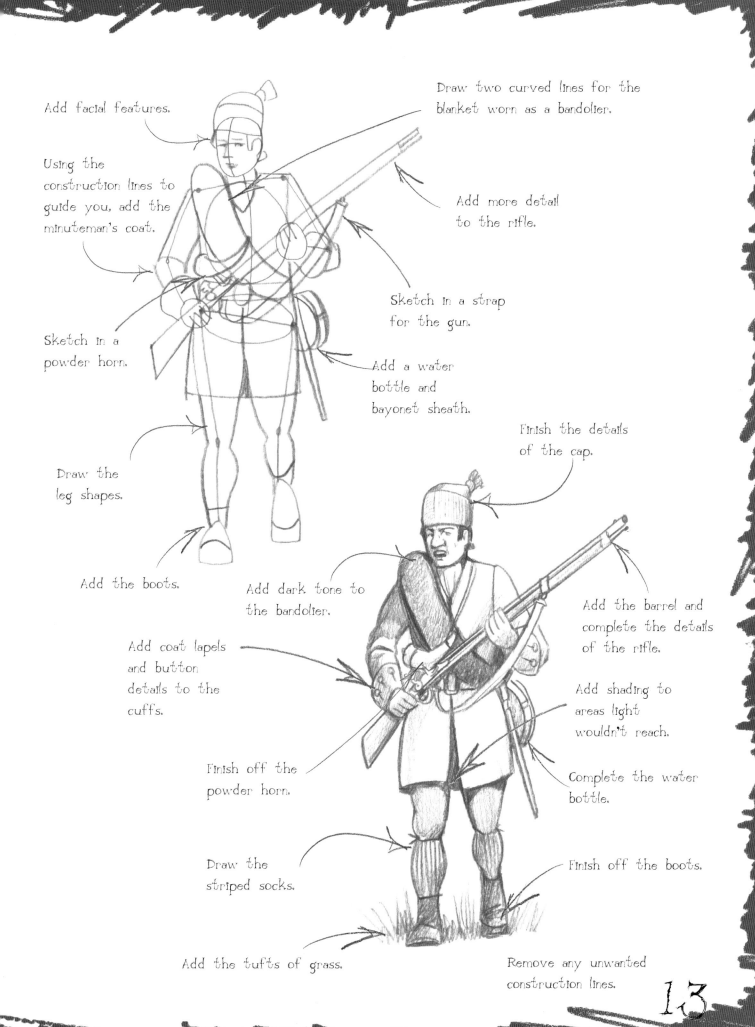

Add facial features.

Using the construction lines to guide you, add the minuteman's coat.

Sketch in a powder horn.

Draw the leg shapes.

Add the boots.

Draw two curved lines for the blanket worn as a bandolier.

Add more detail to the rifle.

Sketch in a strap for the gun.

Add a water bottle and bayonet sheath.

Finish the details of the cap.

Add dark tone to the bandolier.

Add coat lapels and button details to the cuffs.

Finish off the powder horn.

Add the barrel and complete the details of the rifle.

Add shading to areas light wouldn't reach.

Complete the water bottle.

Draw the striped socks.

Finish off the boots.

Add the tufts of grass.

Remove any unwanted construction lines.

13

1776 Redcoat

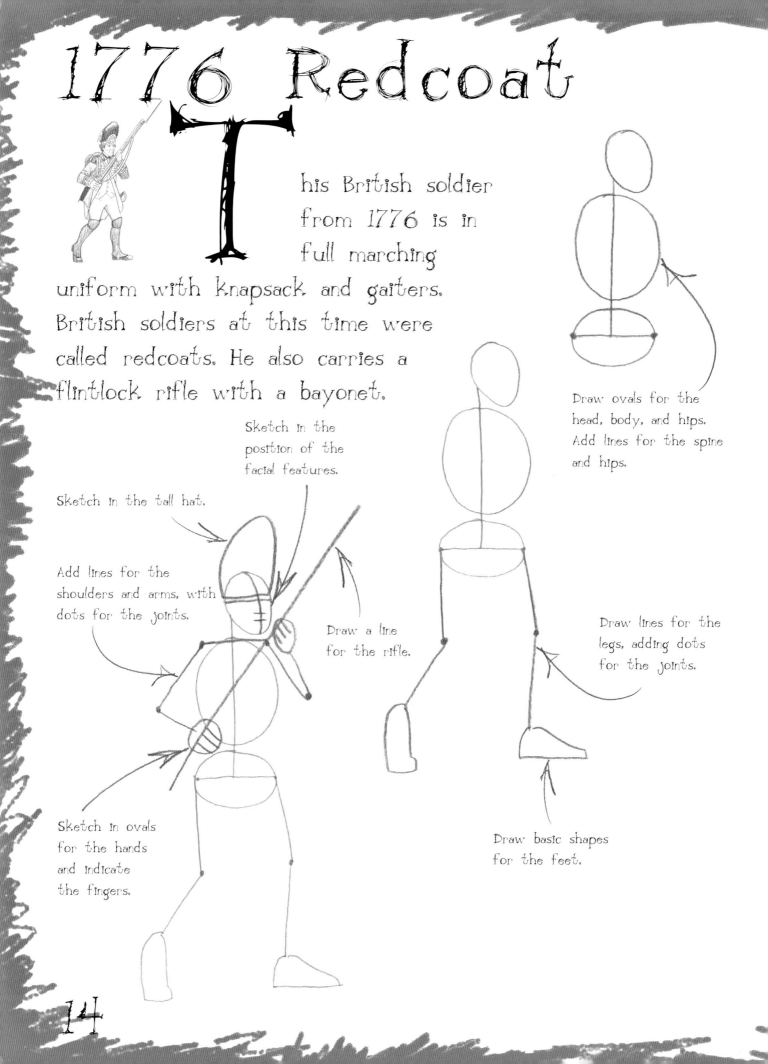

This British soldier from 1776 is in full marching uniform with knapsack and gaiters. British soldiers at this time were called redcoats. He also carries a flintlock rifle with a bayonet.

Draw ovals for the head, body, and hips. Add lines for the spine and hips.

Draw lines for the legs, adding dots for the joints.

Draw basic shapes for the feet.

Sketch in the position of the facial features.

Sketch in the tall hat.

Add lines for the shoulders and arms, with dots for the joints.

Draw a line for the rifle.

Sketch in ovals for the hands and indicate the fingers.

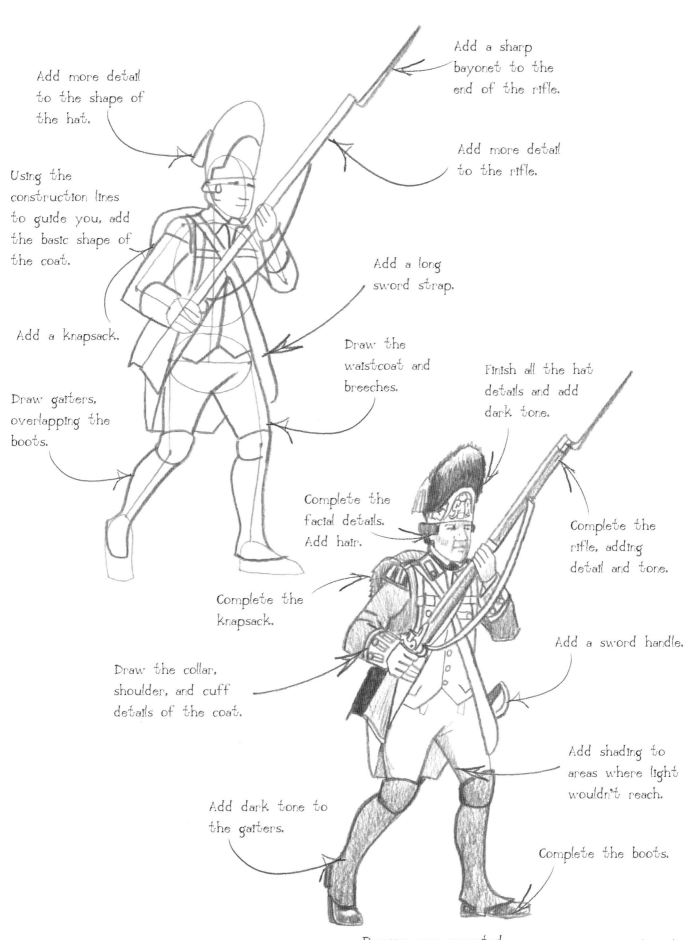

Add more detail to the shape of the hat.

Using the construction lines to guide you, add the basic shape of the coat.

Add a knapsack.

Draw garters, overlapping the boots.

Add a sharp bayonet to the end of the rifle.

Add more detail to the rifle.

Add a long sword strap.

Draw the waistcoat and breeches.

Finish all the hat details and add dark tone.

Complete the facial details. Add hair.

Complete the rifle, adding detail and tone.

Complete the knapsack.

Add a sword handle.

Draw the collar, shoulder, and cuff details of the coat.

Add shading to areas where light wouldn't reach.

Add dark tone to the garters.

Complete the boots.

Remove any unwanted construction lines.

15

Continental Soldier

This is an American Continental soldier from 1775. In that same year George Washington led the Continental army in the American Revolution.

Draw ovals for the head, body, and hips. Add lines for the spine and hips.

Add a line for the shoulders.

Draw in lines for the legs, with dots for the joints.

Draw basic shapes for the feet.

Position the facial features.

Sketch in the shape of the soldier's hat.

Draw a long line for the rifle.

Add ovals for the hands.

Add lines for the arms, with dots for the joints.

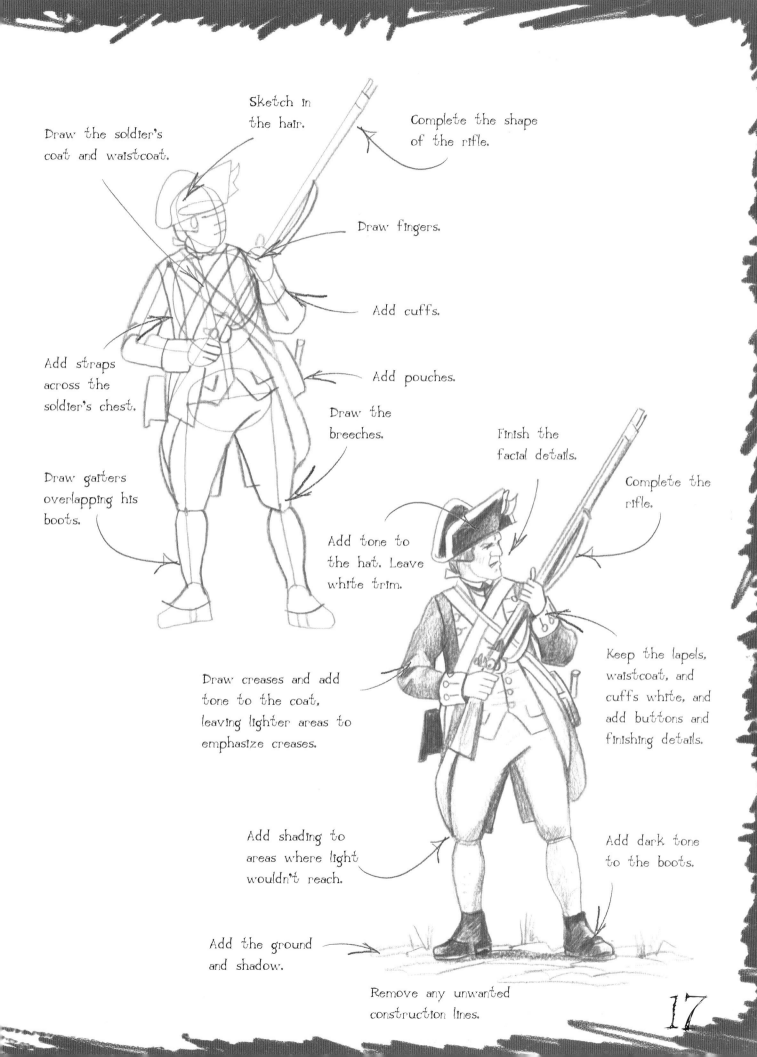

Draw the soldier's coat and waistcoat.

Sketch in the hair.

Complete the shape of the rifle.

Draw fingers.

Add cuffs.

Add straps across the soldier's chest.

Add pouches.

Draw the breeches.

Finish the facial details.

Complete the rifle.

Draw garters overlapping his boots.

Add tone to the hat. Leave white trim.

Draw creases and add tone to the coat, leaving lighter areas to emphasize creases.

Keep the lapels, waistcoat, and cuffs white, and add buttons and finishing details.

Add shading to areas where light wouldn't reach.

Add dark tone to the boots.

Add the ground and shadow.

Remove any unwanted construction lines.

17

1815 Redcoat

T he redcoats formed the core of the troops involved in the Napoleonic wars. They served in the Peninsular War through to the Battle of Waterloo, Belgium, in 1815.

Draw ovals for the head, body, and hips. Add lines for the spine and hips.

Sketch in lines for the arms, with dots for the joints.

Add the cylindrical hat.

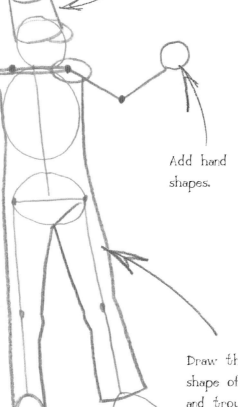

Add hand shapes.

Sketch in lines for the legs, with dots for the joints.

Draw basic shapes for the feet.

Draw the basic shape of the body and trousers.

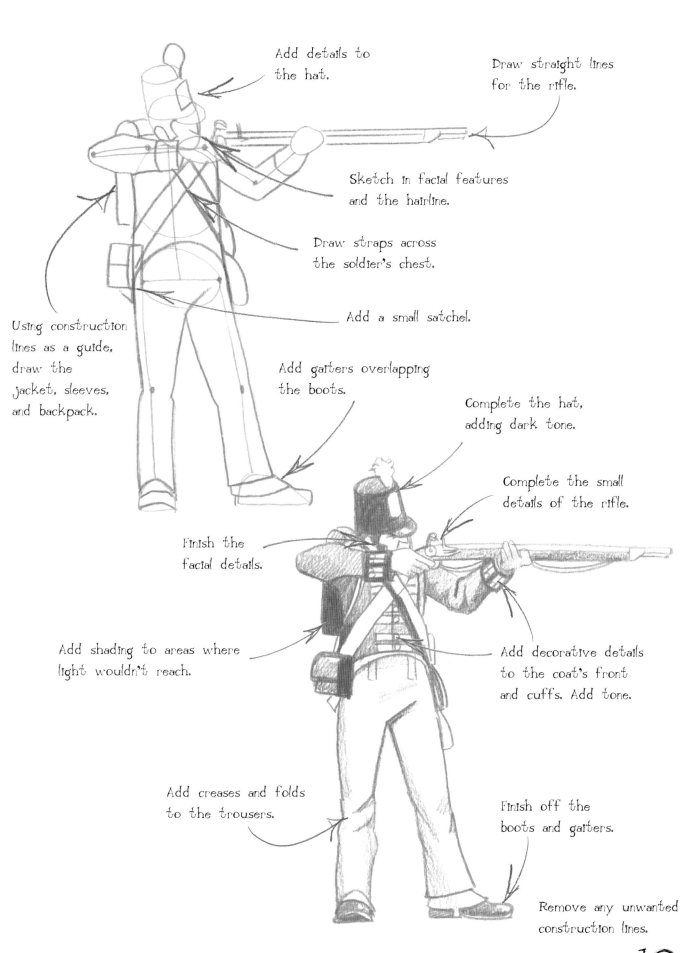

Add details to the hat.

Draw straight lines for the rifle.

Sketch in facial features and the hairline.

Draw straps across the soldier's chest.

Add a small satchel.

Using construction lines as a guide, draw the jacket, sleeves, and backpack.

Add garters overlapping the boots.

Complete the hat, adding dark tone.

Complete the small details of the rifle.

Finish the facial details.

Add shading to areas where light wouldn't reach.

Add decorative details to the coat's front and cuffs. Add tone.

Add creases and folds to the trousers.

Finish off the boots and garters.

Remove any unwanted construction lines.

19

Imperial Guard

The French Imperial Guard were the elite fighting force of Napoleon's army. This soldier is a grenadier of the Imperial Guard.

Draw ovals for the head, body, and hips. Add lines for the spine and hips.

Add a line for the shoulders.

Sketch in lines for the legs with dots for the joints.

Draw basic shapes for the feet.

Draw the basic shape of the large bearskin hat.

Add ovals for the hands.

Mark in the positions of the facial features.

Draw the basic shape of the rifle.

Sketch in lines for the arms, with dots for the joints.

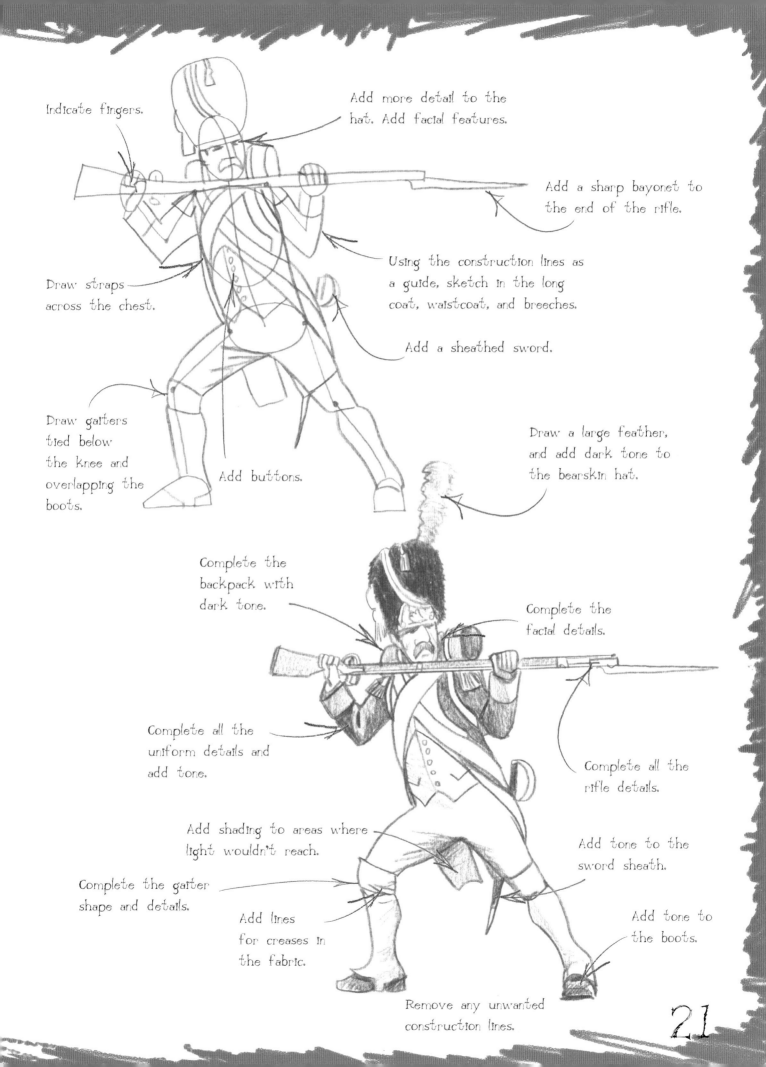

Indicate fingers.

Add more detail to the hat. Add facial features.

Add a sharp bayonet to the end of the rifle.

Using the construction lines as a guide, sketch in the long coat, waistcoat, and breeches.

Draw straps across the chest.

Add a sheathed sword.

Draw gaiters tied below the knee and overlapping the boots.

Draw a large feather, and add dark tone to the bearskin hat.

Add buttons.

Complete the backpack with dark tone.

Complete the facial details.

Complete all the uniform details and add tone.

Complete all the rifle details.

Add shading to areas where light wouldn't reach.

Add tone to the sword sheath.

Complete the garter shape and details.

Add lines for creases in the fabric.

Add tone to the boots.

Remove any unwanted construction lines.

21

Union Soldier

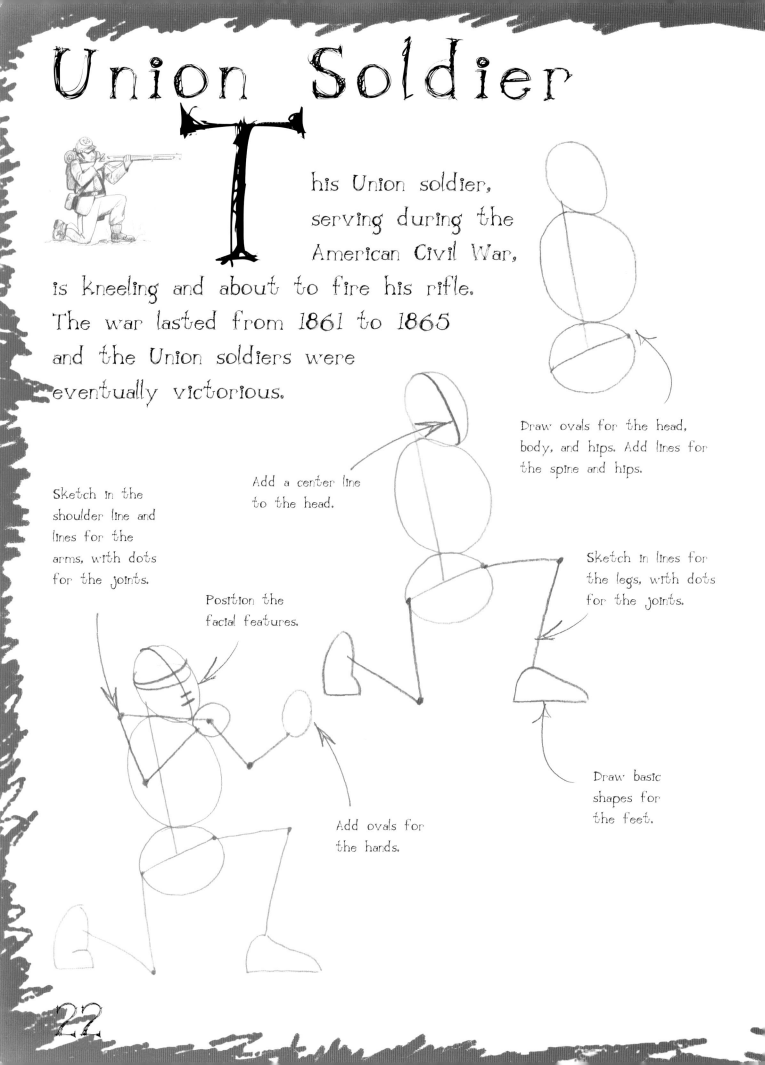

This Union soldier, serving during the American Civil War, is kneeling and about to fire his rifle. The war lasted from 1861 to 1865 and the Union soldiers were eventually victorious.

Draw ovals for the head, body, and hips. Add lines for the spine and hips.

Add a center line to the head.

Sketch in lines for the legs, with dots for the joints.

Sketch in the shoulder line and lines for the arms, with dots for the joints.

Position the facial features.

Draw basic shapes for the feet.

Add ovals for the hands.

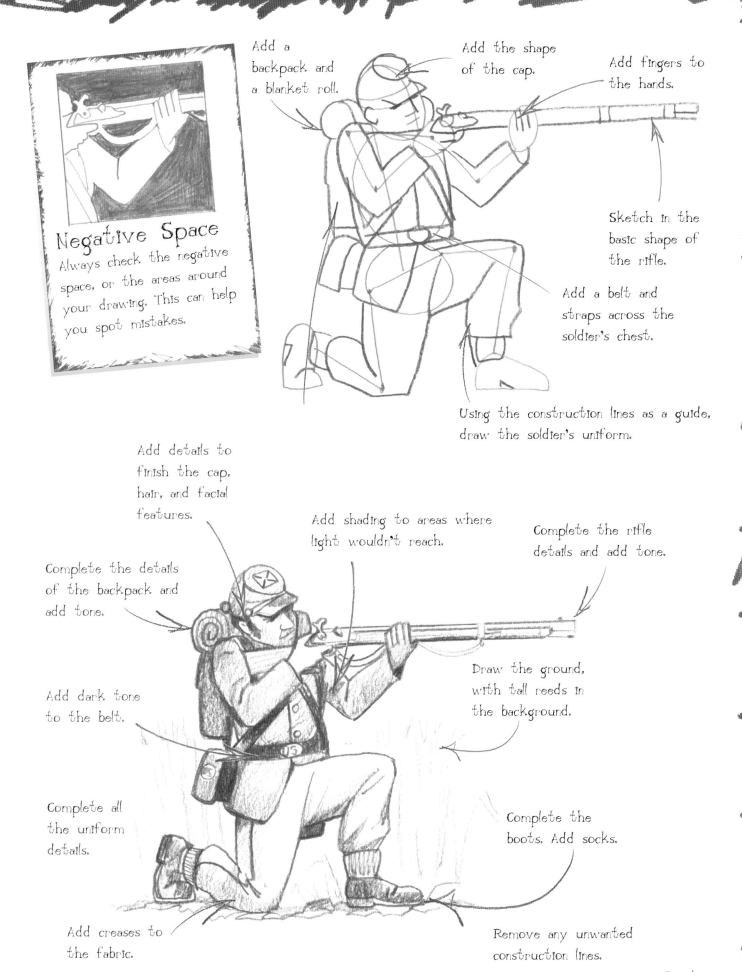

Add a backpack and a blanket roll.

Add the shape of the cap.

Add fingers to the hands.

Sketch in the basic shape of the rifle.

Add a belt and straps across the soldier's chest.

Using the construction lines as a guide, draw the soldier's uniform.

Negative Space

Always check the negative space, or the areas around your drawing. This can help you spot mistakes.

Add details to finish the cap, hair, and facial features.

Add shading to areas where light wouldn't reach.

Complete the rifle details and add tone.

Complete the details of the backpack and add tone.

Add dark tone to the belt.

Draw the ground, with tall reeds in the background.

Complete all the uniform details.

Complete the boots. Add socks.

Add creases to the fabric.

Remove any unwanted construction lines.

23

Confederate Soldier

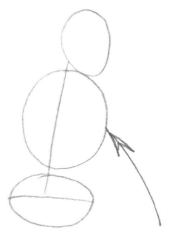

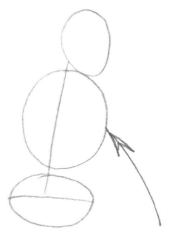

I n the American Civil War the Union was fighting against the Confederacy. This Confederate soldier has his bayonet attached and is ready for conflict.

Draw ovals for the head, body, and hips. Add lines for the spine and hips.

Draw lines for the arms and shoulders, with dots for the joints.

Draw the wide-brimmed hat.

Draw lines for the legs, with dots for the joints.

Mark in the position of the facial features.

Sketch in the basic shape of the feet.

Add ovals for the hands.

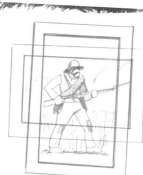

Composition

By framing your drawing with a square or a rectangle, you can make it look completely different.

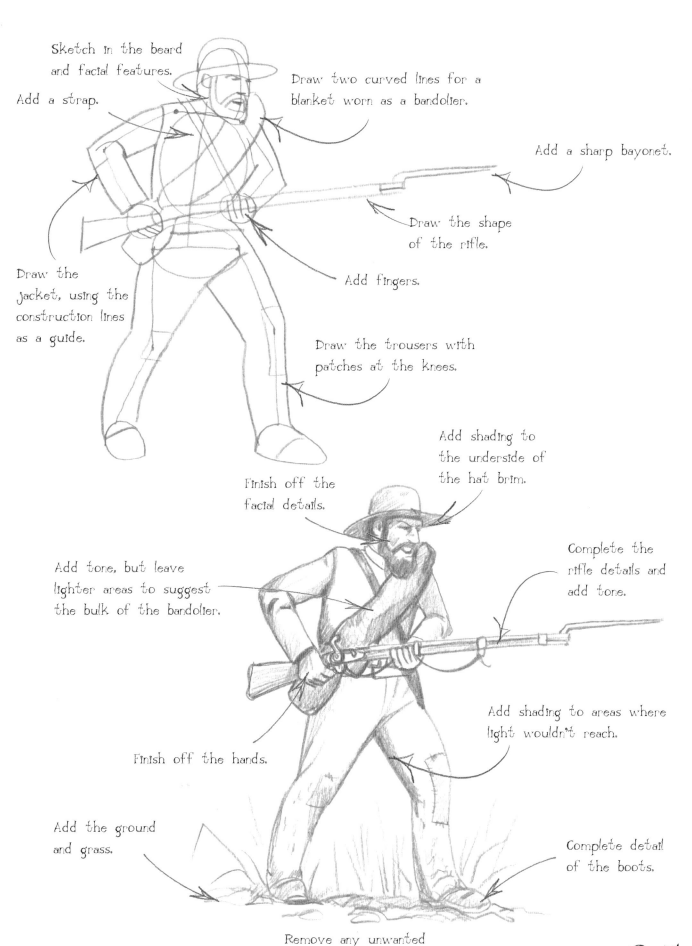

Sketch in the beard and facial features.

Add a strap.

Draw two curved lines for a blanket worn as a bandolier.

Add a sharp bayonet.

Draw the shape of the rifle.

Draw the jacket, using the construction lines as a guide.

Add fingers.

Draw the trousers with patches at the knees.

Add shading to the underside of the hat brim.

Finish off the facial details.

Complete the rifle details and add tone.

Add tone, but leave lighter areas to suggest the bulk of the bandolier.

Add shading to areas where light wouldn't reach.

Finish off the hands.

Add the ground and grass.

Complete detail of the boots.

Remove any unwanted construction lines.

25

British WWI Soldier

World War I began in 1914 and ended in 1918. It was a huge and bloody conflict involving all of the world's most powerful countries at that time. This British soldier is aiming his rifle, ready to fire at the enemy.

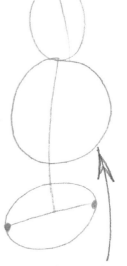

Draw ovals for the head, body, and hips. Add lines for the spine and hips.

Sketch lines for the legs, with dots for the joints.

Draw the basic shape of the feet.

Add the basic helmet shape.

Sketch in lines for the arms and shoulders, with dots for the joints.

Add ovals for the hands.

Draw a line for the rifle.

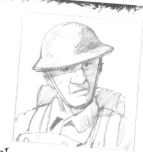

Chiaroscuro
Add dark shading to parts of your drawing for a dramatic effect.

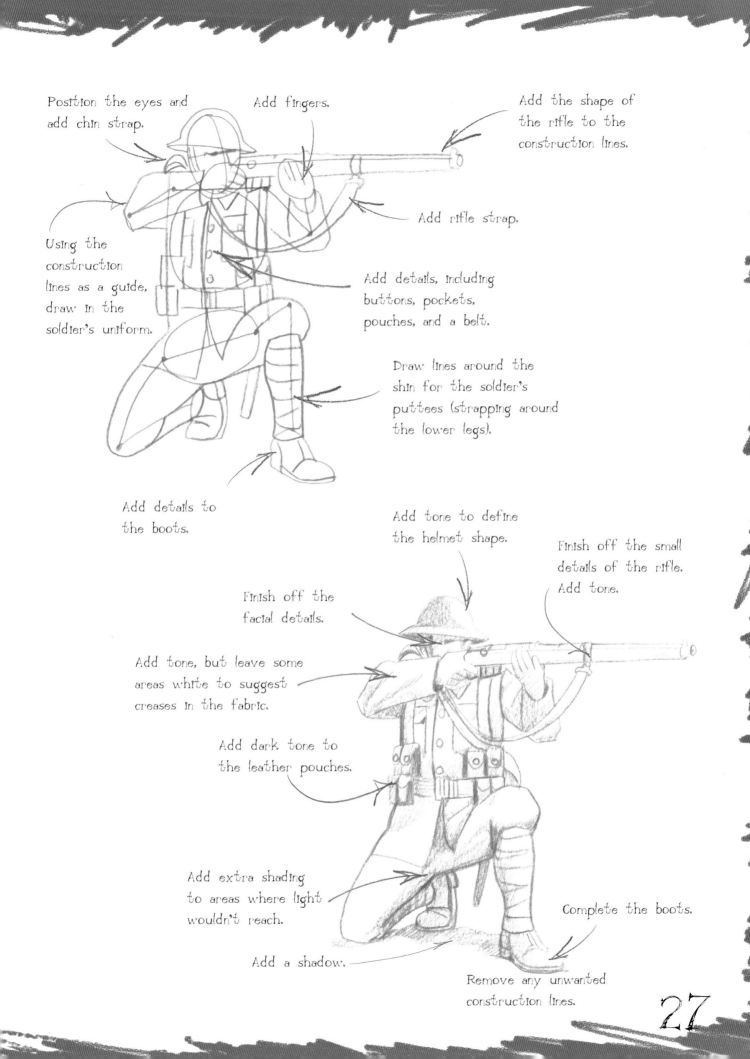

Position the eyes and add chin strap.

Add fingers.

Add the shape of the rifle to the construction lines.

Add rifle strap.

Using the construction lines as a guide, draw in the soldier's uniform.

Add details, including buttons, pockets, pouches, and a belt.

Draw lines around the shin for the soldier's puttees (strapping around the lower legs).

Add details to the boots.

Add tone to define the helmet shape.

Finish off the small details of the rifle. Add tone.

Finish off the facial details.

Add tone, but leave some areas white to suggest creases in the fabric.

Add dark tone to the leather pouches.

Add extra shading to areas where light wouldn't reach.

Complete the boots.

Add a shadow.

Remove any unwanted construction lines.

27

U.S. WWII Soldier

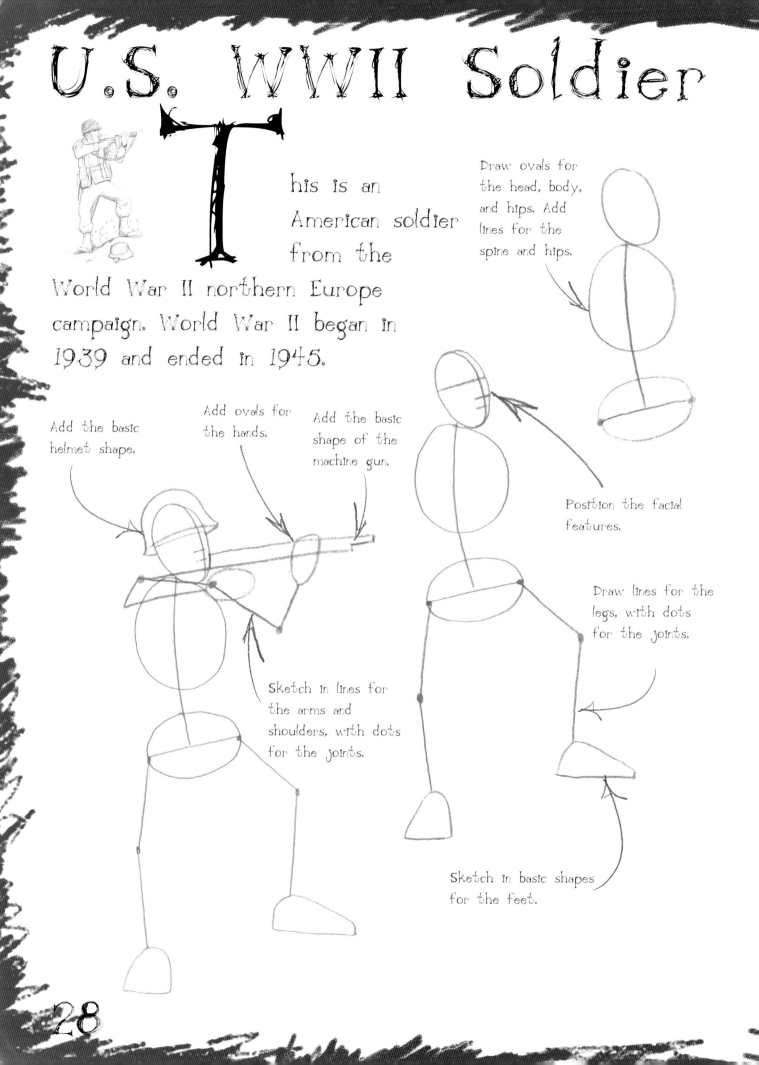

This is an American soldier from the World War II northern Europe campaign. World War II began in 1939 and ended in 1945.

Draw ovals for the head, body, and hips. Add lines for the spine and hips.

Position the facial features.

Add the basic helmet shape.

Add ovals for the hands.

Add the basic shape of the machine gun.

Draw lines for the legs, with dots for the joints.

Sketch in lines for the arms and shoulders, with dots for the joints.

Sketch in basic shapes for the feet.

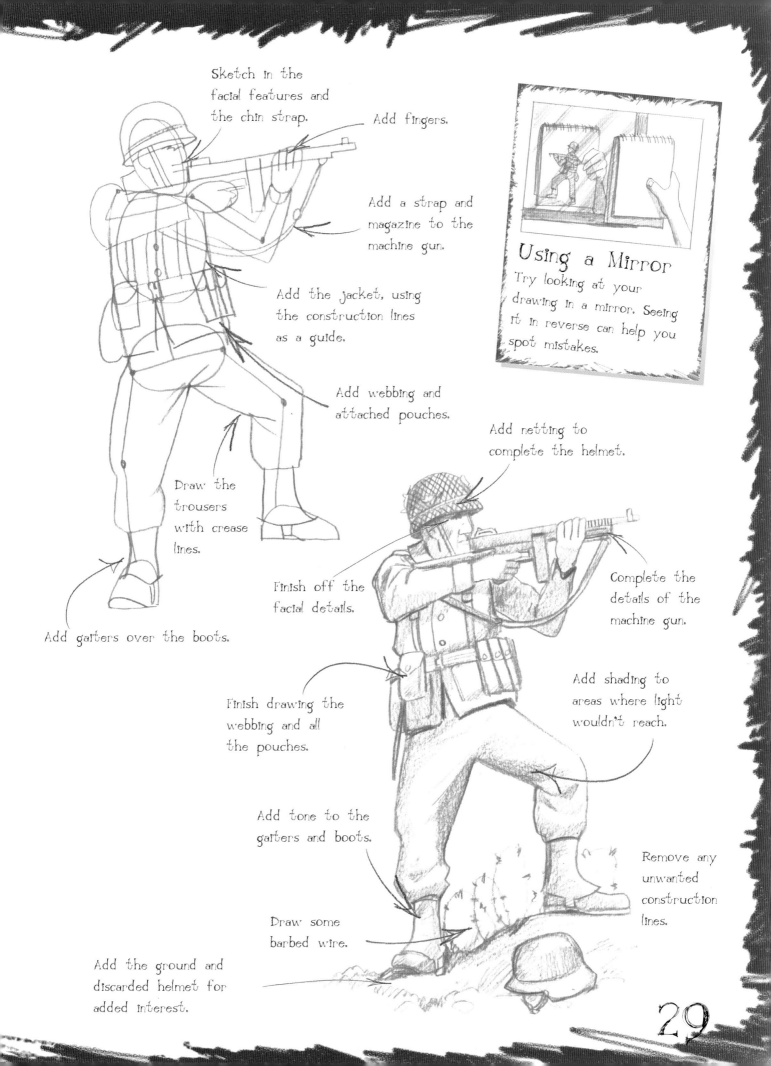

Sketch in the facial features and the chin strap.

Add fingers.

Add a strap and magazine to the machine gun.

Add the jacket, using the construction lines as a guide.

Add webbing and attached pouches.

Draw the trousers with crease lines.

Add garters over the boots.

Using a Mirror
Try looking at your drawing in a mirror. Seeing it in reverse can help you spot mistakes.

Add netting to complete the helmet.

Finish off the facial details.

Complete the details of the machine gun.

Add shading to areas where light wouldn't reach.

Finish drawing the webbing and all the pouches.

Add tone to the garters and boots.

Remove any unwanted construction lines.

Draw some barbed wire.

Add the ground and discarded helmet for added interest.

29

U.S. Infantryman

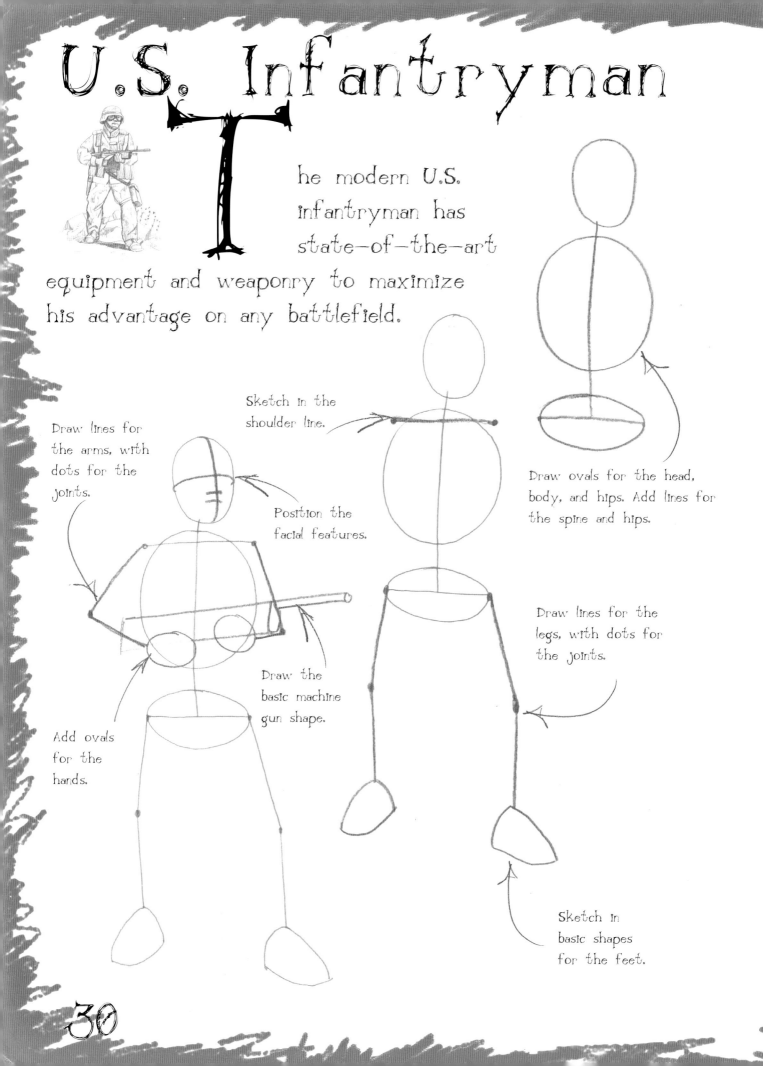

The modern U.S. infantryman has state-of-the-art equipment and weaponry to maximize his advantage on any battlefield.

Draw ovals for the head, body, and hips. Add lines for the spine and hips.

Sketch in the shoulder line.

Draw lines for the legs, with dots for the joints.

Sketch in basic shapes for the feet.

Draw lines for the arms, with dots for the joints.

Position the facial features.

Draw the basic machine gun shape.

Add ovals for the hands.

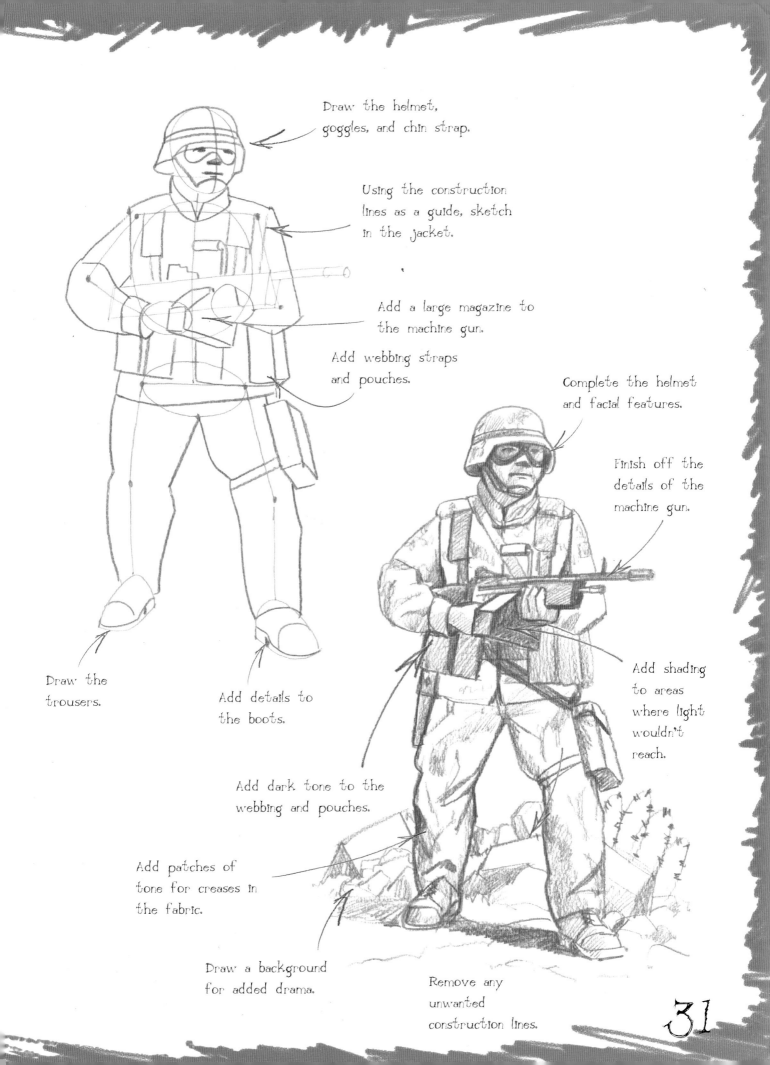

Draw the helmet, goggles, and chin strap.

Using the construction lines as a guide, sketch in the jacket.

Add a large magazine to the machine gun.

Add webbing straps and pouches.

Complete the helmet and facial features.

Finish off the details of the machine gun.

Add shading to areas where light wouldn't reach.

Draw the trousers.

Add details to the boots.

Add dark tone to the webbing and pouches.

Add patches of tone for creases in the fabric.

Draw a background for added drama.

Remove any unwanted construction lines.

31

Glossary

bandolier (ban-duh-lir) A cartridge belt worn across the chest.

bayonet (BAY-oh-net) A knife that can be fixed to the end of a rifle and used as a weapon.

chiaroscuro (kee-AHR-uh-skyur-oh) The practice of drawing high contrast pictures with a lot of black and white but not much gray.

construction lines (kun-STRUK-shun LYNZ) Guidelines used in the early stages of a drawing. They are usually erased later.

garters (GAY-terz) Cloth that covers the ankles.

magazine (MA-guh-zeen) A container for feeding cartridges into the firing chamber of a machine gun.

perspective (per-SPEK-tiv) A method of drawing in which near objects are shown larger than faraway objects.

puttees (PUH-teez) Woolen strips wrapped around a soldier's lower legs to provide support for his legs and ankles.

silhouette (sih-luh-WET) A drawing that shows only a flat dark shape, like a shadow.

vanishing point (VA-nish-ing POYNT) The place in a perspective drawing where parallel lines appear to meet.

Index

Web Sites

Due to the changing nature of Internet links, PowerKids Press has developed an online list of Web sites related to the subject of this book. This site is updated regularly. Please use this link to access the list:

www.powerkidslinks.com/htd/soldier/